# Sutra Copying:

**Ornamenting and Enshrining the Buddhist Dharma
through Advanced Calligraphy**

# Sutra Copying:
Ornamenting and Enshrining the Buddhist Dharma
through Advanced Calligraphy

# Sutra Copying:
Ornamenting and Enshrining the Buddhist Dharma
through Advanced Calligraphy

# Sutra Copying:
Ornamenting and Enshrining the Buddhist Dharma
through Advanced Calligraphy

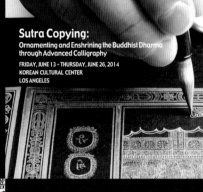

# Sutra Copying:
Ornamenting and Enshrining the Buddhist Dharma
through Advanced Calligraphy

FRIDAY, JUNE 13 – THURSDAY, JUNE 26, 2014
KOREAN CULTURAL CENTER
LOS ANGELES

# Sutra Copying:
Ornamenting and Enshrining the Buddhist Dharma
through Advanced Calligraphy

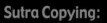

# Sutra Copying:
Ornamenting and Enshrining the Buddhist Dharma
through Advanced Calligraphy

# Sutra Copying:
Ornamenting and Enshrining the Buddhist Dharma
through Advanced Calligraphy

# Sutra Copying:
Ornamenting and Enshrining the Buddhist Dharma
through Advanced Calligraphy

# Sutra Copying:
Ornamenting and Enshrining the Buddhist Dharma
through Advanced Calligraphy

# Sutra Copying:
Ornamenting and Enshrining the Buddhist Dharma
through Advanced Calligraphy

## Sutra Copying:
Ornamenting and Enshrining the Buddhist Dharma
through Advanced Calligraphy

FRIDAY, JUNE 13 – THURSDAY, JUNE 26, 2014
KOREAN CULTURAL CENTER
LOS ANGELES

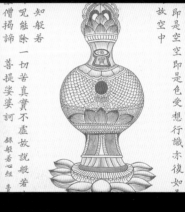

# Sutra Copying:
Ornamenting and Enshrining the Buddhist Dharma
through Advanced Calligraphy

# Sutra Copying:
Ornamenting and Enshrining the Buddhist Dharma
through Advanced Calligraphy

## Explanatory Notes

This publication is a catalog of the works created by the members of the Korean Transcribed Sutra Research Association for their 9th exhibition that is sponsored by the Korean Cultural Center, Los Angeles.

This catalog consists of four parts.
    · Part one includes the works of the officers of the Association and the Supporting Members. (p.10-p.39)
    · Part two consists of the supporting works and the articles that describes the Korean traditional sutra transcription (p.40-p.55)
    · Part three includes the works of the regular members of the Association (p.58-p.73)
    · Part four contains the photos of the activities of the Association (p.76-p.79)

2. The size of the works has been specified according to length × width.

3. The name of the creator is written on the basis of their name as it appears in their passport, listing given name first, and surname second.

4. The profiles of the artists list up to four most important experience or works.

5. According to each author, sagyeong is differently translated into 'Sutra Painting,' 'Illuminated Sutra,' 'Transcribed Sutra,' or 'Sutra-Copying.'

Dancheong Publishing.
Ginam Building 201, 18-15 Second Avenue,
Pildong, Jung-gu, Seoul, Korea 100-272

Printed in the Republic of Korea.

Korean Transcribed Sutra Research Association
 · 126 (2nd Floor) Yeonhi-ro, Seodaemun-gu, Seoul, Republic of Korea
 · Mobile. +82-10-4207-7186    · E-mail : kikyeoho@hanmail.net

Design and Edition by SeoYeaMunWha Calligraphy Culture Magazine

ISBN 978-89-959593-7-4

The designs of the front and back pages are from the work of Oegil Kim Kyeong Ho titled "Traditional illuminated Sutra-Copying in Conversation with Bible-Copying, Koran-Copying, and Mandala Ⅰ" (p.42-p.43)

The 9th Exhibition of the Korean Transcribed Sutra Research Association

# Sutra Copying:

## Ornamenting and Enshrining the Buddhist Dharma through Advanced Calligraphy

JUNE 13 - JUNE 26, 2014

KOREAN CULTURAL CENTER, LOS ANGELES

PRESENTED BY

한국문화원
KOREAN CULTURAL CENTER
LOS ANGELES

한국사경연구회
Korean Transcribed Sutra Research Association

# Congratulatory Remarks

I am honored and pleased to have the "Sutra Copying: Ornamenting and Enshrining the Buddhist Dharma through Advanced Calligraphy" by the Korean Sutra Transcription Research Association at the Korean Cultural Center, Los Angeles.

Sagyeong is sutra transcription and illumination by hand that was purposely developed during the Goryeo period (918-1392). During that time, Buddhism was officially supported by the King and state, which led to flourishing Buddhist arts. It is a window into the minds and souls of the Korean people and it represents the culture of Korea through the arts.

This exhibition features over 40 works through the participation of artists from the Korean Sutra Transcription Research Association from Korea. This exhibition is undoubtedly a great opportunity for everyone to experience the art of Sagyeong. I hope this exhibition will allow all communities, and not just Korean and Korean-American communities to experience Sagyeong that capture the true beauty of Korean culture.

Lastly, I would like thank Kyeong Ho Kim, Artist & President of Korean Sutra Transcription Research Association and congratulate all the participating artists in this exhibition and I truly wish this event to be successful.

June, 2014

Youngsan Kim
Director & Consul
Korean Cultural Center, Los Angeles

# Sutra Copying:
## Ornamenting and Enshrining the Buddhist Dharma
## through Advanced Calligraphy

Sutra transcription has 1700-year history. It is an art as well as a religious practice that enables one to make the teaching of the Buddhist sutras his own while copying those sutras. The transcribed sutras from this practic are magnificent works of art.

Comparable tradition in the western civilization would be transcription and decoration of the Bible or Koran.

In Buddhist culture the merit of sutra transcription is highly valued along with that of *suji*(embracing and retaining the precepts and teachings), recitation of sutras and Dharma talks. Since sutra transcription is considered a sacred act, the transcriber seeks the highest level of purity in terms of body and mind, as well as tools and supplies. It is a requirement to keep the mind devoid of all greed, anger, and ignorance while transcribing. Transcribed sutras are revered and cherished because they are the results of this rigorous practice.

Sutra transcription can beconsidered a grand art form; the culmination of the 1700 years of tradition that combines the spirituality and the core concept of aesthetics of the Korean people.

The tradition of sutra transcription experienced serious decline during the 600 years of Chosun dynasty (1392-1910) when Buddhism fell from favor. Recently, however, sutra transcription has gained recognition for its artistry and the historical importance. Moreover it is being considered as the antidote to the modern day symptoms of stress and impatience due to its nature of slowness and value of purity and intricacy.

Korean Transcribed Sutra Research Association upholds the tradition of the Koryeo dynasty (918-1392) when the sutra transcription peaked in terms of artistry and technique and leads the efforts to modernize this important tradition and to overcome the boundaries of religion.

I would like to extend my deepest gratitude to Mr. Youngsan Kim and Ms. Heeseon Choi, the Director and the curator of Korean Cultural Center, Los Angeles, respectively, for giving us the opportunity to introduce the exquisite works of the members of the Korean Transcribed Sutra Research Association. I would also like to thank the artists who participated in this exhibit. They have truly poured their hearts and soul into these marvelous works of art.

It is my sincere hope that this exhibit brings us another step closer to a world where diverse cultures, religions, and arts can share with each other the beauty and the spirituality for peace and happiness for all.

Oegil Kim Kyeong Ho
President, Korean Transcribed Sutra Research Association

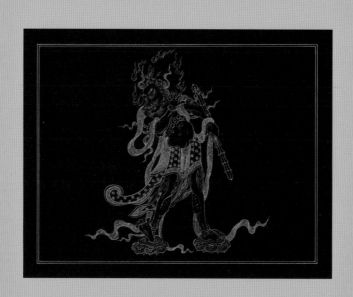

# Chapter 1: Chapter of Wisdom

| | |
|---|---|
| Kyung-Ae Kang | Gye-Joon Park |
| Choong-Mo Kang | Gap-Sook Oh |
| Myung-Rim Kim | Kyung-Nam Yoon |
| Bong-Whan Kim | Mi-Yeong Jo |
| Young-Ae Kim | Hae-Ja Choi |
| Jong-Song Kim | Haeng-O (Dharma name) |
| Jung-Ja Mo | : Haeng-Im Lee |
| Jin-Hyung Mock | Young-Ja Heo |

# Kyung-Ae Kang

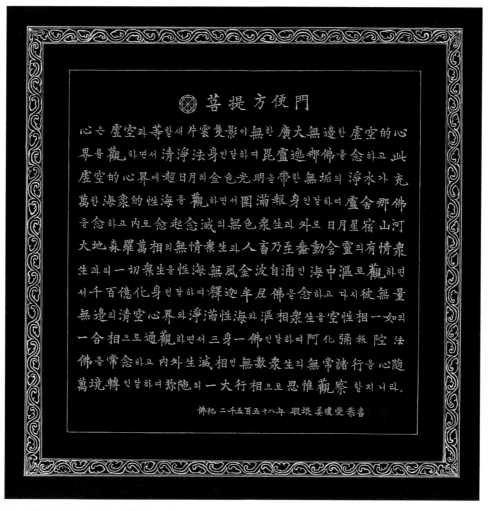

Gate of Boddhi Upaya (wise skillful means) / *indigo blue paper, a gold amalgam, a silver amalgam, 55 × 55 cm*

· Invited to the Sutra Transcription Exhibit at the World Calligraphy Biennale of Jeollabuk-do
· Invited Artist, Competition in Calligraphy and Culture
· Participated in the exhibitions of the Korean Transcribed Sutra Research Association members

· 503-1301 Poonglim Apt, Koyang-dong, Deukyang-gu, Koyang-si, Gyeonggi-do, South Korea
· Mobile. +82+10-6392-4422

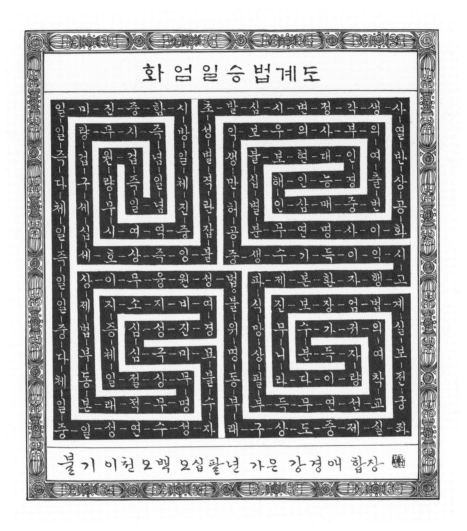

The Hwaeom One Vehicle Dharma Realm Chart / *traditional Korean paper handmade from mulberry trees and red paper, a silver amalgam, red ink stick, 45 × 36 cm*

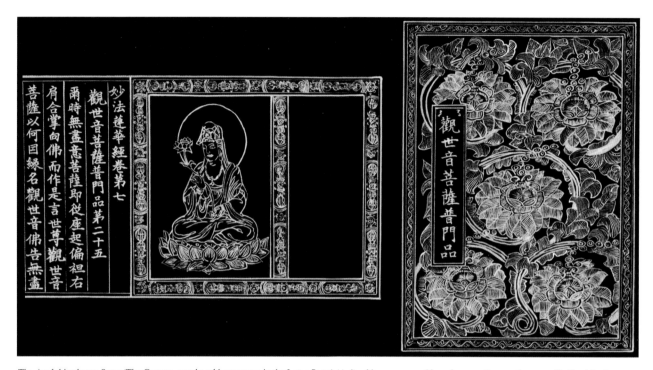

The Avalokiteshvara Sutra (The Gwanse-eum bosal bomunpum in the Lotus Sutra) / *indigo blue paper, a gold amalgam, a silver amalgam, a rolled book having a spindle, 30 × 340㎝*

· Invited Artist, Competition in Calligraphy and Culture

· Participated in the exhibitions of the Korean Transcribed Sutra Research Association members

· Prizewinner at many calligraphy and sutra transcription Competitions

· 84-1304 Hyundai Apt, Apgujeong-dong, Gangnam-gu, Seoul, South Korea

· Mobile. +82+10-4117-6133

義相祖師 法性偈

法性圓融無二相　諸法不動本來寂
無名無相絶一切　證智所知非餘境
真性甚深極微妙　不守自性隨緣成
一中一切多中一　一即一切多即一
一微塵中含十方　一切塵中亦如是
無量遠劫即一念　一念即是無量劫
九世十世互相即　仍不雜亂隔別成
初發心時便正覺　生死涅槃常共和
理事冥然無分別　十佛普賢大人境
能仁海印三昧中　繁出如意不思議
雨寶益生滿虛空　衆生隨器得利益
是故行者還本際　叵息妄想必不得
無緣善巧捉如意　歸家隨分得資糧
以陀羅尼無盡寶　莊嚴法界實寶殿
窮坐實際中道床　舊來不動名為佛

佛紀二五五八年一月 姜忠模頓首書

Master Uisang's Beopseong-ge (Verse of Dharma Nature) / *indigo blue paper, a gold amalgam, 33×49㎝*

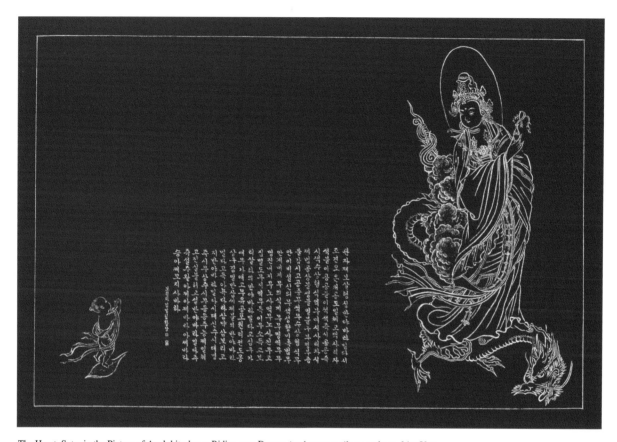

The Heart Sutra in the Picture of Avalokiteshvara Riding on a Dragon / *red paper, a silver amalgam, 34 × 50㎝*

· Invited to the Sutra Transcription Exhibit at the World Calligraphy Biennale of Jeollabuk-do
· Invited Artist, Competition in Calligraphy and Culture
· Private Exhibitions of Sutra Transcription

· Jinsan village 703-903, Pungduckchon 2-dong, Suji-gu, Yongin-si, Gyeonggi-do, South Korea
· Mobile. +82+10-8961-9365

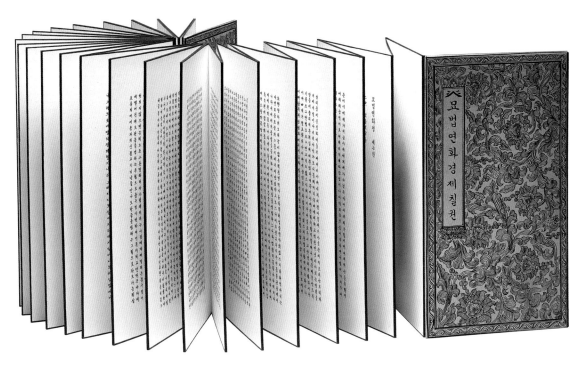

The Lotus Sutra Vol. 7 / *traditional Korean paper handmade from mulberry trees, Ink Stick,*
*a book made by folding linked paper with covers at the front and back, 32 × 18㎝ × 48*

ㅎ여둘러싸여이사바세계,
ㄴ나내려서석가모니불께머리숙여,
늘리며부처님께여쭈었다세존이시여정,
ㅡ그만병도조그만고뇌도없으시며기거가자,
四대가잘조화되나이까세상일을가히참을수외
탐욕과성냄과어리석음과질투와인색함과교만
하지않으며사문을공경하지않는일은없나이까
五욕에빠지는일은없나이까중생이모든마군이
ㄴ도하신다보여래께서는보탑과함께법을들
ㅔ께도문안하여조그만고뇌도없으시고,
하였나이다세존이시여재가지금
신견토록해주옵소서그,

# Bong-Whan Kim

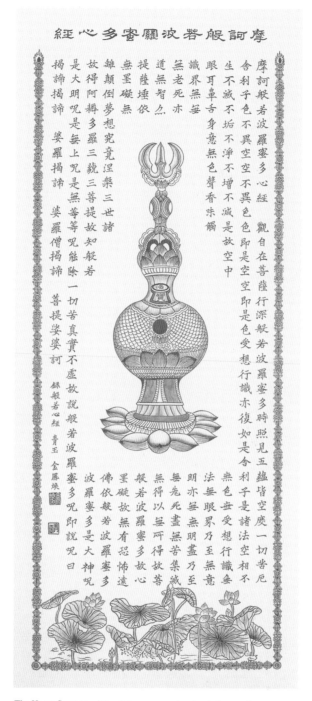

The Heart Sutra / *traditional Korean paper handmade from mulberry trees, red ink stick, 33 × 78㎝*

· Invited Artist, Competition in Calligraphy and Culture
· Participated in the exhibitions of the Korean Transcribed Sutra Research Association members
· Prizewinner at many calligraphy and sutra transcription Competitions

· 202 Riverpark, 984-29, Geomsa-dong, Dong-gu, Daegu-si, South Korea
· Mobile. +82+10-7708-9922

# 般若心經

摩訶般若波羅蜜多心經

觀自在菩薩行深般若波羅蜜多時照見五蘊皆空度一切苦厄

舍利子色不異空空不異色色即是空空即是色受想行識亦復如是舍利子是諸法空相不

生不滅不垢不淨不增不減是故空中無色無受想行識無眼耳鼻舌身意無色聲香味觸法

無眼界乃至無意識界無無明亦無無明盡乃至無老死亦無老死盡無苦集滅道無智亦無

得以無所得故菩提薩埵依般若波羅蜜多故心無罣礙無罣礙故無有恐怖遠離顛倒夢想

究竟涅槃三世諸佛依般若波羅蜜多故得阿耨多羅三藐三菩提故知般若波羅蜜多是大

神呪是大明呪是無上呪是無等等呪能除一切苦真實不虛故說般若波羅蜜多呪即說呪

曰 揭諦揭諦 波羅揭諦 婆羅僧揭諦 菩提娑婆訶 黃金莊嚴 青玉 金鳳煥

The Heart Sutra / *indigo blue paper, a gold amalgam, 124×48cm*

# Young-Ae Kim

Bible <Song of Solomon> / *indigo blue paper, a silver amalgam, a book whose backbone is laced up with a string,*
*24.5 × 17.5 cm × 42*

· Invited Artist, Competition in Calligraphy and Culture
· Participated in the exhibitions of the Korean Transcribed Sutra Research Association members
· Prizewinner at many calligraphy and sutra transcription Competitions

· 410-7, Hongeun-dong, Seodaemun-gu, Seoul, South Korea
· Mobile. +82+10-9645-0215

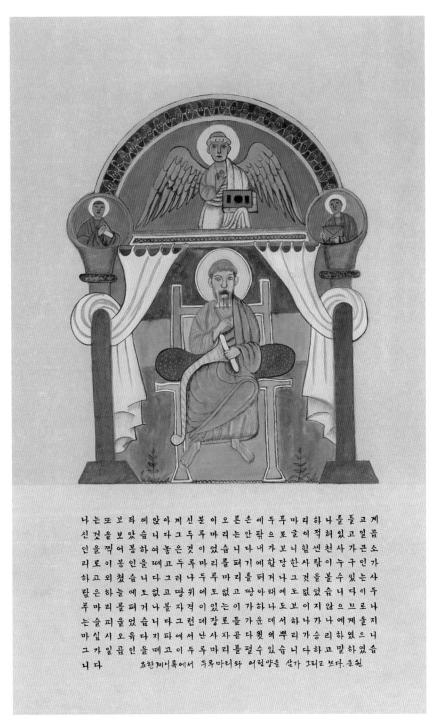

나는또보좌에앉아계신분이오른손에두루마리하나를들고계
신것을보았습니다그두루마리는안팎으로글이적혀있고일곱
인을찍어봉하여놓은것이었습니다내가보니힘센천사가큰소
리로이봉인을뗴고두루마리를펴기에합당한사람이누구인가
하고외쳤습니다그러나두루마리를펴거나그것을볼수있는사
람은하늘에도없고땅위에도없고땅아래에도없었습니다이두
루마리를펴거나볼자격이있는이가하나도보이지않으므로나
는슬피울었습니다그런데장로들가운데서하나가나에게울지
마십시오유다지파에서난사자곧다윗의뿌리가승리하였으니
그가일곱인을뗴고이두루마리를펼수있습니다하고말하였습
니다    요한계시록에서 두루마리와 어린양을 산가 그리고 쓰다. 운원

Bible <Book of Revelation of St. John - the Scroll and the Lamb> / *yellow paper, color paint, Ink Stick, 59 × 36㎝*

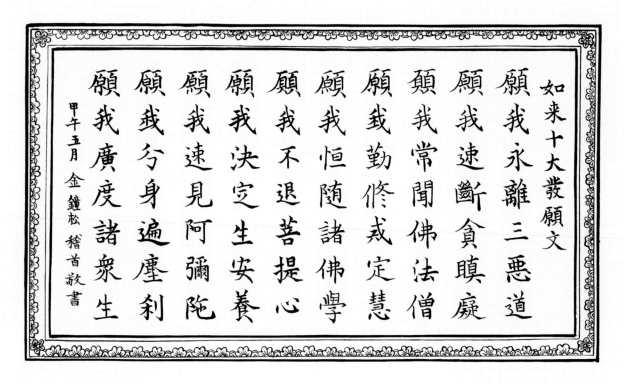

如来十大發願文
願我永離三惡道
願我速斷貪瞋癡
願我常聞佛法僧
願我勤修戒定慧
願我恒隨諸佛學
願我不退菩提心
願我決定生安養
願我速見阿彌陀
願我分身遍塵刹
願我廣度諸衆生

甲午五月 金鐘松 稽首敬書

Tathagata's Ten Great Written Vows / *traditional Korean paper handmade from mulberry trees, ink stick, 29×45㎝*

· Participated in the exhibitions of the Korean Transcribed Sutra Research Association members

· Prizewinner at many calligraphy and sutra transcription Competitions

· Kunyoung Farm, 526-1, Saneung-ri, Jingeon-eub, Namyangju-si, Gyeonggi-do, South Korea

· Mobile. +82+10-9290-4386

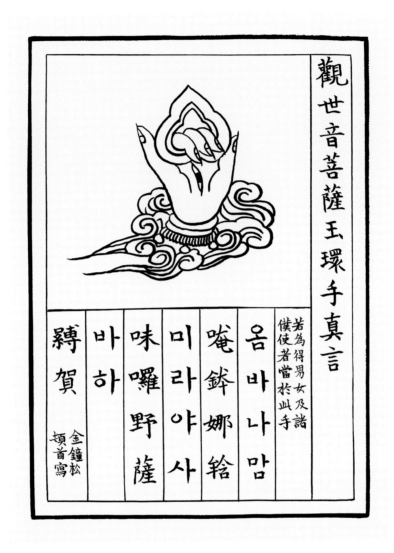

Avalokiteshvara's True Word for Getting a Son, a Daughter, or a Servant / *traditional Korean paper handmade from mulberry trees, ink stick, 45 × 33 ㎝*

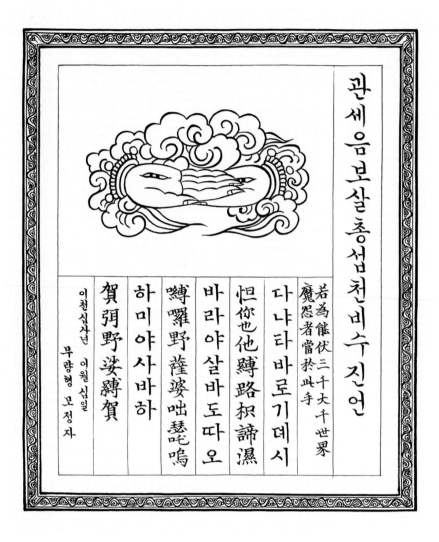

Avalokiteshvara's True Word for Making Evil Demons Surrender / *traditional Korean paper handmade from mulberry trees, ink stick, 27 × 23㎝*

· Invited Artist, Competition in Calligraphy and Culture

· Participated in the exhibitions of the Korean Transcribed Sutra Research Association members

· Prizewinner at many calligraphy and sutra transcription Competitions

· Jugong Greenbill Apt. 804-602, Gojan-dong 766, Danwon-gu, Ansan-city, Gyeonggi-do, South Korea

· Mobile. +82+10-5477-4609

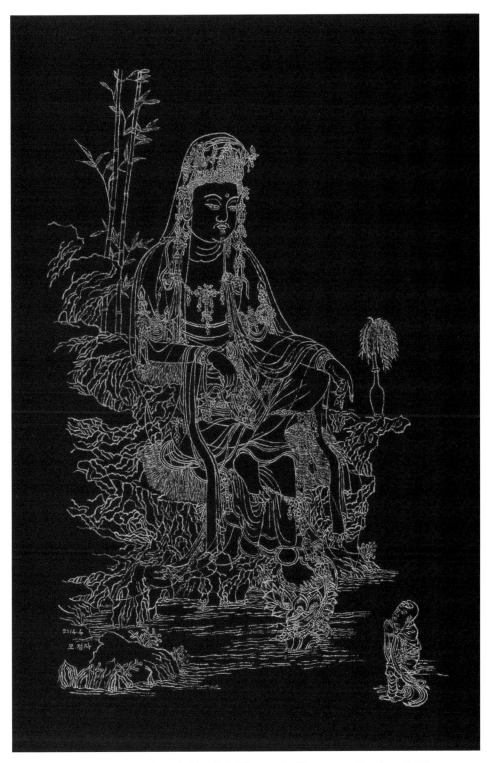

The Picture of Avalokiteshvara Gazing at the Moon in the Water  / *indigo blue paper, a gold amalgam, 53×39㎝*

# Jin-Hyung Mock

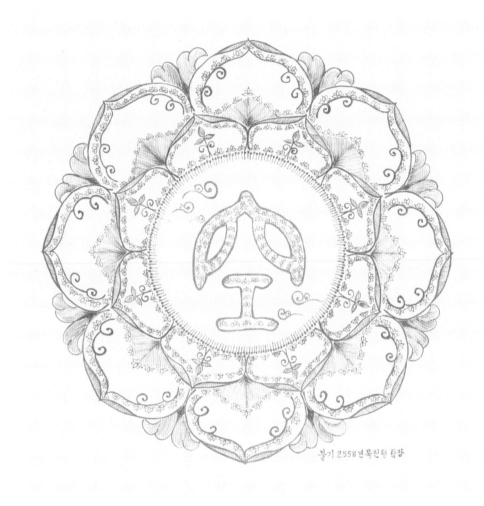

<Sunyata> Mandala / *traditional Korean paper handmade from mulberry trees, a gold amalgam, 36 × 36㎝*

· Invited to the Sutra Transcription Exhibit at the World Calligraphy Biennale of Jeollabuk-do
· Invited Artist, Competition in Calligraphy and Culture
· Private Exhibitions of Sutra Transcription

· Jin-San Village 703-801 Pungduckchon-2 dong, Suji-gu, Yongin-si, Gyeonggi-do, South Korea, 448-549
· Mobile. +82+10-7310-3554

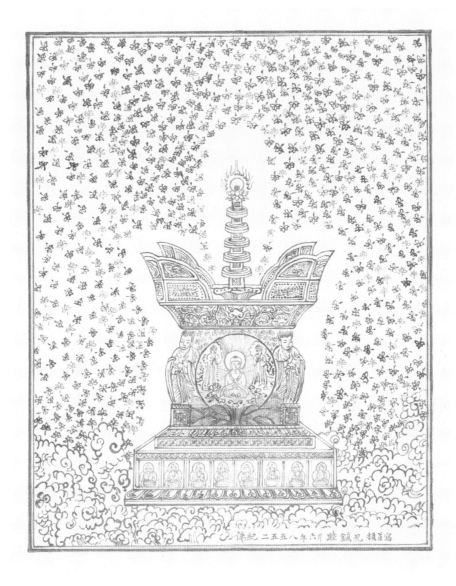

Image of Bohyeopin stupa / *traditional Korean paper handmade from mulberry trees, a gold amalgam, 30 × 24㎝*

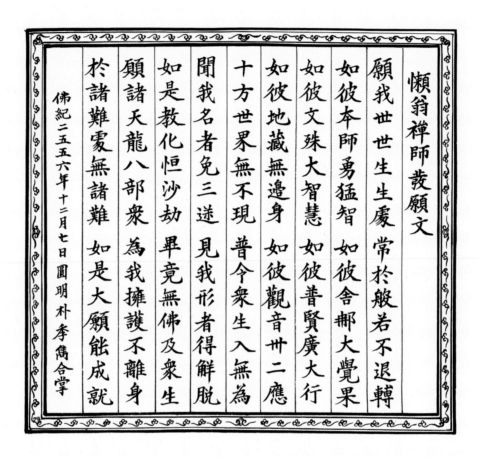

A Written Vow of the National Preceptor Naong / *traditional Korean paper handmade from mulberry trees, ink stick, 31 × 33 cm*

· Participated in the exhibitions of the Korean Transcribed Sutra Research Association members
· Prizewinner at many calligraphy and sutra transcription Competitions

· 209-802, Dongyang Apt, Beodnae-2danji, Taepyong-dong, Jung-gu, Daejeon-si, South Korea, 301-150
· Mobile. +82+10-5428-2332

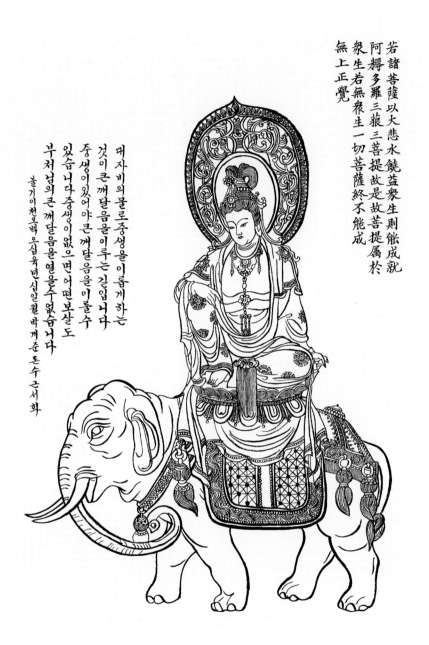

若諸菩薩以大悲水饒益眾生則能成就
阿耨多羅三藐三菩提故是故菩提屬於
眾生若無眾生一切菩薩終不能成
無上正覺

대자비의 물로 중생을 이롭게 하는
것이 큰 깨달음을 이루는 길입니다
중생이 있어야 큰 깨달음을 이룰 수
있습니다 중생이 없으면 어떤 보살도
부처님의 큰 깨달음을 얻을 수 없습니다
글기이천오백 오십육년 사월 파께춘 도수 근서화

The Verse in the Picture of Samanthabhadra Bodhisattva / *traditional Korean paper handmade from mulberry trees, ink stick, 52×40cm*

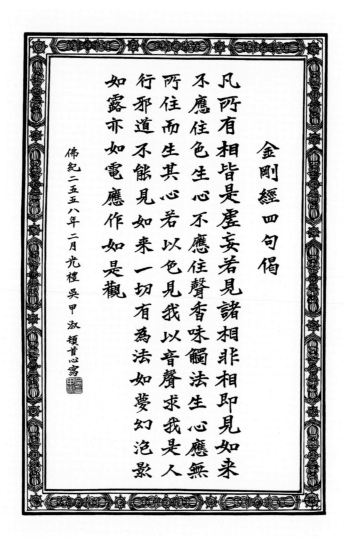

Diamond Sutra Stanza of Four Lines / *traditional Korean paper handmade from mulberry trees, ink stick, 36 × 23 cm*

· Invited Artist, Competition in Calligraphy and Culture
· Participated in the exhibitions of the Korean Transcribed Sutra Research Association members
· Prizewinner at many calligraphy and sutra transcription Competitions

· 1109-405, Lotte Castle, Hwanggeum-dong, Suseoung-gu, Daegu-si, South Korea
· Mobile. +82+10-9383-6073

The Ten Verses in the Parental Benevolence Sutra / *traditional Korean paper handmade from mulberry trees, ink stick*

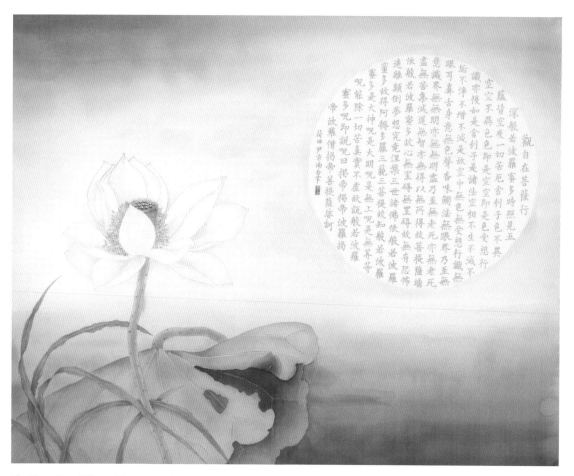

The Heart Sutra / *Silk, a gold amalgam, color paint, 41 ×51㎝*

· Invited Artist, Competition in Calligraphy and Culture

· Participated in the exhibitions of the Korean Transcribed Sutra Research Association members

· Prizewinner at many calligraphy and sutra transcription Competitions

· 212-1504, Cheongsong Hyundai Apt, Janggi-dong, Gimpo-si, Gyeonggi-do, South Korea

· Mobile. +82+10-3744-9794

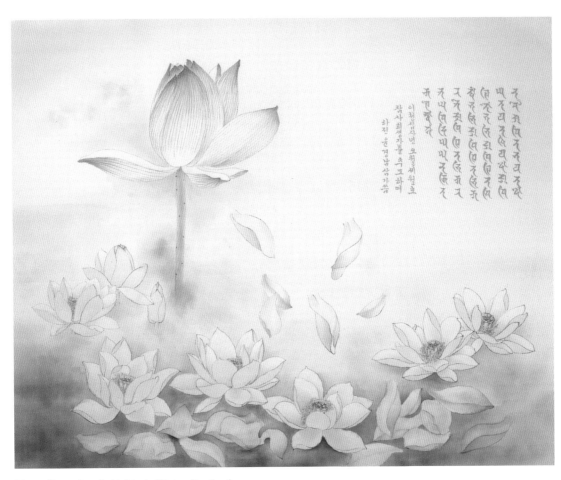

Matra of invocation of rebirth in the Western Pure Land
/ *Silk, a gold amalgam, color paint, 41 × 51 cm*

# Mi-Yeong Jo

Empty Zen meditation rood / *yellow paper, Ink Stick, 50×40㎝*

· Ph.D.

· Successor of the functions of the Traditional Sutra Write

· Wonkwang University part-time lecturer

· Invited to the Sutra Transcription Exhibit at the World Calligraphy Biennale of Jeollabuk-do

· 763-1 Gueok-li, Yongjin-myeon, Wanju-gun, Jeollabuk-do, South Korea

· Mobile. +82+10-3047-3977

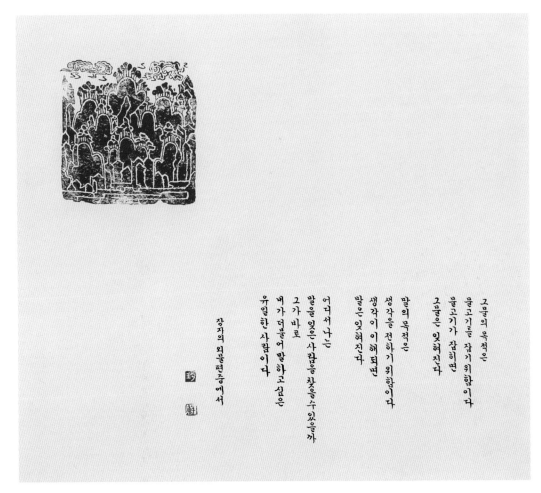

장자의 외물편중에서

그물의 목적은
물고기를 잡기 위함이다
물고기가 잡히면
그물은 잊혀진다

말의 목적은
생각을 전하기 위함이다
생각이 이해되면
말은 잊혀진다

어디서 나는
말을 잊은 사람을 찾을 수 있을까
그가 바로
내가 더불어 말하고 싶은
유일한 사람이다

From Zhuangzi's<Outer Chapters> / *yellow paper, Ink Stick, 30 × 40㎝*

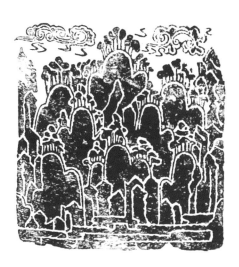

# Hae-Ja Choi

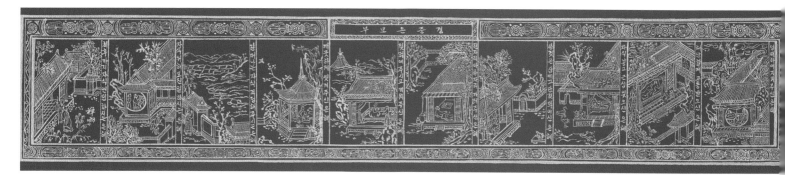

The Ten Verses in the Parental Benevolence Sutra / *red paper, a gold amalgam, 12 × 60㎝*

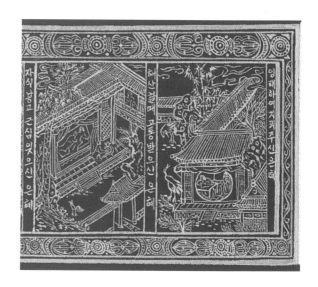

· Invited to the Sutra Transcription Exhibit at the World Calligraphy Biennale of Jeollabuk-do
· Invited Artist, Competition in Calligraphy and Culture
· Private Exhibitions of Sutra Transcription

· 307-505, Metropalais, Manchon-dong, Sooseung-gu, Daegu-si, South Korea, 706-953
· Mobile. +82+10-6244-5787

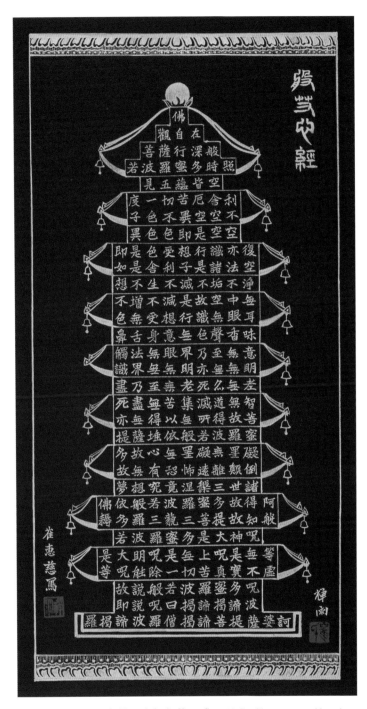

The Picture of the Jeweled Pagoda in the Heart Sutra / *indigo blue paper, a gold amalgam,*
*42 × 28㎝*

# Haeng-O (Dharma name) : Haeng-Im Lee

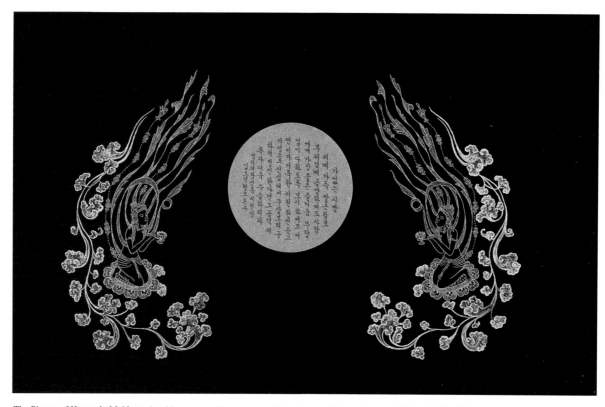

The Picture of Heavenly Maids / *indigo blue paper, yellow paper, a gold amalgam, a silver amalgam, red ink stick, 40 × 63㎝*

· Invited to the Sutra Transcription Exhibit at the World Calligraphy Biennale of Jeollabuk-do
· Invited Artist, Competition in Calligraphy and Culture
· Lectured on Sutra Copying at the Cultural Center of Buddhism TV
· Currently Directing Traditional Sutra Copying at Kilsang-am(temple)

· Gilsang-am(temple) 538-107, Donam2-dong, Seongbuk-gu, Seoul, South Korea
· Mobile. +82+10-3868-4336

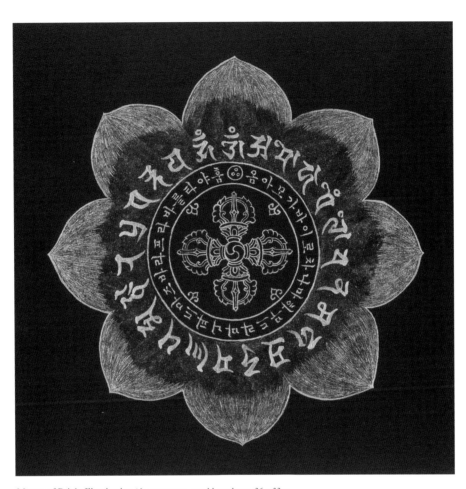

Mantra of Bright Illumination / *brown paper, a gold amalgam, 36×33㎝*

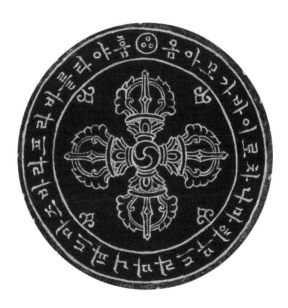

# Young-Ja Heo

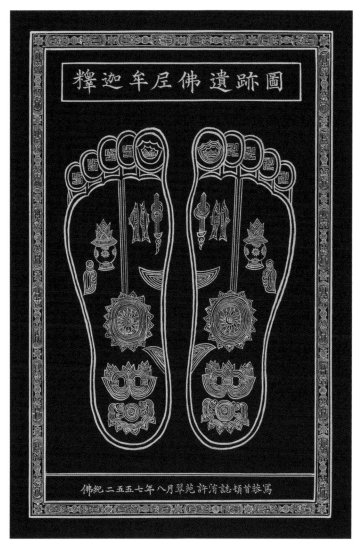

釋迦牟尼佛遺跡圖

佛紀二五五七年八月翠苑許消誌頓首恭寫

The Picture of the Sakyamuni Buddha's Remains / *indigo blue paper, a gold amalgam, 51×48㎝*

· Invited to the Sutra Transcription Exhibit at the World Calligraphy Biennale of Jeollabuk-do
· Invited Artist, Competition in Calligraphy and Culture
· Private Exhibitions of Sutra Transcription

· 109-301, Dongbang Miju Apt, Sanggye 1-dong, Nowon-gu, Seoul, South Korea
· Mobile. +82+10-8789-5874

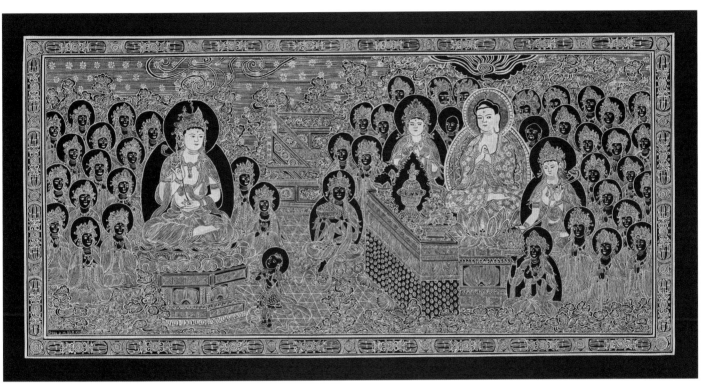

The Illustrated Painting of the Chapter on the Vows of Samantabhadra in the Flower Adornment Sutra / *indigo blue paper, a gold amalgam, 25.5 × 53cm*

# Chapter 2: Guest works, and some articles which explain Korean traditional sagyeong works

## Kim Kyeong-Ho (Oegil : the Only Path)

1. Korea Traditional Skills Transmitter (Ministry of Employment and Labor)
2. The President of the Korean Tanscribed Sutra Research Association
3. Grand Prize in the First Korean Buddhist Scripture Transcribing Contest (Jogye Order and Eastern Calligraphers' Association)
4. Fifteen (15) Individual Exhibitions in Traditional Buddhist Scripture Transcribing Art in Seoul, Los Angeles, and New York.
5. Invited Artist and Commissioner in International Calligraphers' Exhibition held in Jeonjoo
6. Instructor of Korean Buddhist Scripture Transcribing at Yonsei University, Dongguk University, Dong A Daily Newspaper Cultural Center, Buddhist Cultural Center, Buddhist TV Cultural Center, Wongwang University (Department of Calligraphy)
7. Instructor in "Another Practice, Transcribing Sutra" 25 series in Buddhist TV
8. Provided instruction and demonstration in various occasions at New York Korean Cultural Center, National Museum of Korea, Korea University (Department of Education, Highest Level of Calligraphy) and Los Angeles County Museum of Art
9. Researched, invested, consulted on, and restored important national treasures (Cultural Heritage Administration of Korea, and General Affairs in Jogye Order)
10. Authored "Korean Art of Transcribing of Buddhist Sutra" (introduction of Art of Transcribing of Buddhist Sutra) and "Kim Gyeong Ho" (Collection of Kim Gyeong Ho's art works)

· http:/blog.naver.com/eksrnswkths
· http://cafe.daum.net/sakyoung
· 126 (2nd Floor) Yeonhi-ro, Seodaemun-gu, Seoul, Republic of Korea
· Mobile. +82-10-4207-7186   · E-mail : kikyeoho@hanmail.net

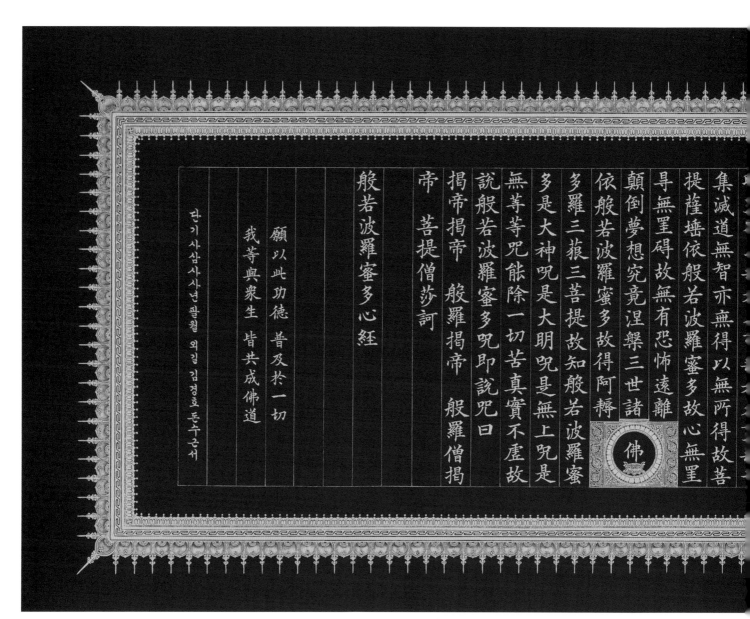

Traditional illuminated Sutra-Copying in Conversation with Bible-Copying, Koran-Copying, and Mandala · 1" (32.2 cm in length/84 cm in width), written with a gold amalgam on dark blue paper

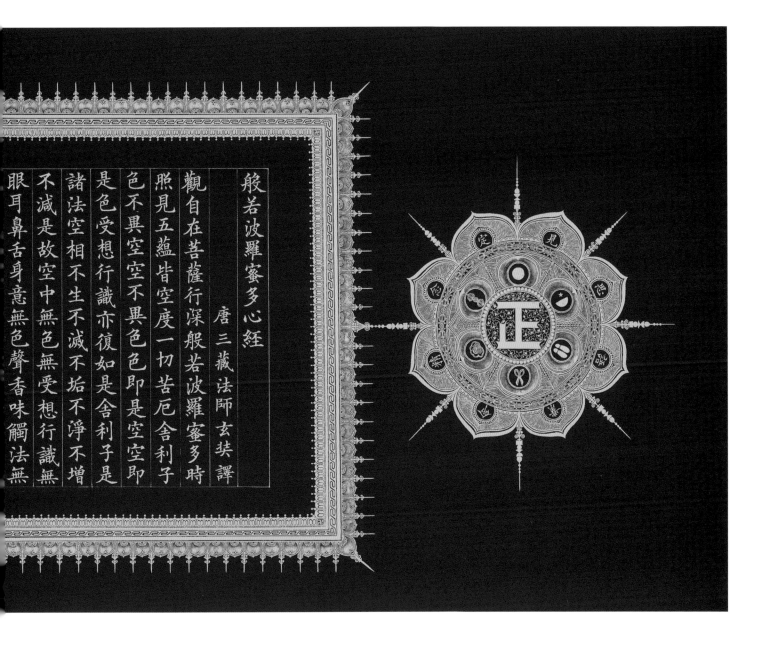

般若波羅蜜多心経

唐三藏法師玄奘譯

観自在菩薩行深般若波羅蜜多時

照見五蘊皆空度一切苦厄舍利子

色不異空空不異色色即是空空即

是色受想行識亦復如是舍利子是

諸法空相不生不滅不垢不淨不增

不減是故空中無色無受想行識無

眼耳鼻舌身意無色聲香味觸法無

# Guest work: Kyeong-Ho Kim

Seven-storied jeweled pagoda "The Chapter of the Vision of the Jeweled Pagoda in the Lotus Sutra" (7.5cm in length/663cm in width), written with a gold amalgam on dark blue paper

# Guest work: Kyeong-Ho Kim

# The Value and Significance of Korean Traditional Sutra-Copying (Sagyeong) in World History

Sagyeong (the copying out of sutras, Buddhist scriptural passages) is a religious practice which involves not only transcribing the words of truth that Buddhist saints have passed down, but imprinting them on one's mind, and reflecting upon them; at the same time, it is a calligraphic creational action that contributes to the attainments of morality, insightful meditation, wisdom, and the control of good and evil, as revealed in Buddhist scriptures. That is, sagyeong is a religious practice, wherein the body and mind are focused on oneness with the truth, and wherefore that oneness with the truth is reflected in the physical movements involved with calligraphy; such that, without a lapse of concentration, the calligrapher-cum-religious practitioner expresses inner truth with a dot and a stroke, whilst using only the most purified materials and tools. The resulting calligraphic art (suitable for display, and also referred to as "a Sa-gyeong") is regarded as the result of a very noble and pure practice, and could become highly valued as a work of art.

It is assumed that the practice of sagyeong in Korea had begun by the year 372 A.C.E., the year when Buddhism was officially accepted by the Gogryeo Kingdom, yielding about 1,700 years of history and tradition. That tradition has not been static, however, it has developed and evolved as a way of symbolically expressing the beauty, intelligence and accumulated knowledge of the time. (In the current age, the desire for a distinct form of individual expression has increased.) The artistry of sagyeong suggests cleanliness, solitude, and magnificence, a highly spiritual aesthetic which has as its basis Buddhist textual passages regarded as the ultimate expressions of truth.

As a highly significant cultural artifact, the artistic value of sagyeong can be summarized in these ten points:
1) The practice of sagyeong can be viewed as the progenitor of the printing profession. As printing disseminates written words, the development of printing is central to the extension, accumulation, and transmission of knowledge and culture; additionally, civilizational development is closely related with printing. Korea is the birthplace of such printing. The Great Dharani Sutra of the Immaculate and Pure Light (Korean national treasure #126) is the oldest extant woodblock print; and the Essentials of Pointing to the Mind's Essence (Jikji simche yojeol) is the oldest extant book produced from metal type in the world.

Since the oldest extant materials printed from woodblocks, and those printed from fixed metal type, are Korean sagyeong relics, we can say that sagyeong practice was the original source for the development of woodblock and fixed metal type printing skills. Thus, Koeran sagyeong has value and significance from the standpoint of world history.
2) The most beautiful sagyeong art in the history of world Buddhist art was produced during the Goryeo Dynasty in Korea. This appraisal of the Goryeo Dynasty's sagyeong art means that that era's artifacts best

capture the essence of the Buddhist sagyeong aesthetic. Although at first the Goryeo Kingdom received sagyeong practice from Chinese sources, and then transmitted those techniques to Japan, the sagyeong practice of the Goryeo Kingdom went beyond simply imitating and following the techniques of the Chinese. The Goryeo Kingdom's sagyeong evolved beyond the techniques of the original Chinese transmission, so much so that the new improved Korean techniques were gallantly re-exported to China during the Yuan Dynasty, which had secured the widest continent in the world. It can be said that sagyeong is one of the major fields in which Korea had far surpassed China, with the re-exporting of specialists on a large scale.

A record of the relevant historical facts is contained in the Goryeosa (The History of the Goreyo Dynasty). Reading this history, and surveying the extant sa-gyeong relics, we can ascertain that as many as 100 sagyeong-monks were dispatched to the Yuan Kingdom, several times, and that they copied the Chinese Tripitaka (the Buddhist cannon traditionally categorized into three divisions) with gold and silver ink. Sometimes Chinese envoys came to the Goryeo Kingdom to produce the Tripitaka in gold and silver ink, and then carried their work back to China. It is impossible to copy the Tripitaka in gold and silver ink unless the practitioner has training in a special technique, and has a deep spiritual practice. Thus, the fact that this was one of the works copied means that the sagyeong standard of the Goryeo Kingdom was very high. It can be said that the Goryeo Kingdom's sagyeong reached the highest standard among the countries where Buddhism had been transmitted.

3) Sagyeong is the culture and art that represents one of the greatest achievements of the Goryeo Dynasty. According to the Goryeosa (The History of the Goreyo Dynasty), six thousand volumes of the Tripitaka were produced in gold ink during the Goryeo Dynasty (918~1392), as were six thousand volumes in silver ink; furthermore, this feat was repeated a total of ten times. Three copies of the Tripitaka in woodblock were also produced (the Chojo Tripitaka, the Collection of Teachings, and the Jaejo Tripitaka). (To create the first woodblock Tripitaka, a Baekjimukseo [meaning 'transcribed into white paper with an ink stick' ] Panhwa-version [meaning 'corrected and proofread version' ] Tripitaka should first be copied; thus, the Baekjimukseo Tripitaka must also have been copied at least three times.) Add to this sagyeongs that were produced by each temple, and those that were copied by the aristocrats, including the royal family, and we cannot guess the enormous number of sutra copyings produced. If we consider the innumerable copies of the woodblock Tripitaka, we are bound to say that the Goryeo Dynasty could as well be known as the 'Sagyeong Dynasty.'

4) From the time of Buddhism's introduction in the Three Kingdom Period, down through to the Unified Silla Period, many Buddhist monks were the most excellent intellectuals, pioneers who introduced advanced products of civilization, and sagyeong-artisans who had the best professional skills and created exquisite sagyeong relics. In addition, in the history of Korean calligraphy, we can't overlook that from the Unified Silla Period to the Goryeo Dynasty, a number of master calligraphers were monks well-versed in calligraphy, and that they took part in the making of sagyeong relics. For example, there were masters of calligraphy such

as Kim Saeng, who worked during the Unified Silla Period, Master Tanyeon, who worked during the Goreyo Period, and prince Anpyeong, who worked during the early days of the Joseon Dynasty.

5) The copying was conducted with a vow to achieve the peace of the four oceans (the whole world), and the safety and happiness of the country and the people beyond the individualistic level of stability and a favorable change in fortune; thus, sagyeong practice helped to pioneer universality in the history of Korean cultural sensibilities. The tendency to dedicate sagyeong works to the peace of the four oceans and the well-being of the nation had begun to be noticeable since the late Unified Silla, and peaked during the Goryeo Dynasty. People in the Goryeo Dynasty copied the Tripitaka in silver ink and gold ink, and made woodblock prints of the Tripitaka several times, in the belief that doing so would help to overcome the aggression of foreign powers. To do this effectively, according to the Goryeosa, the Goryeo Dynasty ran a 'sagyeong-won' (sagyeong center) and created ten copies of the Tripitaka in gold ink, ten copies in silver ink, and ten woodblock prints; which, if it were true, would be unparalleled in world history. The characteristic of the use to which sagyeong printing of texts was put, that is, as part of a sympathetic magic ritual for world peace, the development of mankind, and the preservation of the nation and the state, means that the spirit involved here was a universal one, not simply a parochial one.

6) About fifty sagyeong relics have been designated as national treasures and normal treasures. When the secondary sagyeong relics (in which the original sagyeong relics were housed) are included, more than two hundred sagyeong relics have been designated as National Important Cultural Properties. That amounts to ten percent of all state-designated cultural properties, and it is the greatest percentage for any single cultural property. This fact also enables us to see how much value sagyeong relics have, and how important sagyeong works have been to the culture and art of Korea.

Among such sagyeong relics there are those that have value from the standpoint of world history. As mentioned above, the Dharani of the Pure Immaculate Light, the number 126 national treasure of Korea, is the oldest extant woodblock print relic in the world. The Dafangguangfo huayan jing, the number 196 national treasure, is a baekjimukseo (a print transcribed into white paper with a stick dipped in ink) that could be the first example of ancient calligraphy in the history of Korea. The Diamond Sutra carved in a gold plate, the number 123 national treasure, is the only sagyeong carved in a gold plate in the world written in Chinese characters. Additionally, the Koreana Tripitaka, the number 32 national treasure, which is registered as a UNESCO World Heritage Record, also has value from the standpoint of world history, in that it is the one and only extant complete set of woodblock Tripitaka prints in the world. The remaining books of the Tripitaka in gold and silver ink, which were copied during the Goryeo Dynasty, are also relics which should be regarded in a new light from the viewpoint of world history.

7) When the history of Korean calligraphy is discussed, the importance of sagyeong work can never be overlooked. For example, among the extant oldest calligraphy relics written in an individual's own

handwriting (primary historical records of calligraphy) there is the Silla's baekjimukseo-version of the Dafangguangfo huayan jing, the No. 196 national treasure. This sagyeong relic can be said to be a result of our Korean forefather's 'victory of the human spirit', and it is a flower in the history of Korean calligraphy. Although it is composed of very tiny characters, only 6 mm in size, all of the dots and strokes perfectly embody the elements of calligraphy. In addition, in the extant two chuks (the central spindle, made of wood, is called a chuk; here, this spindle is used to count the number of books) of this gweon-ja-bon (A rolled book having a spindle), there are one hundred and thirty thousand Chinese characters, no "misspellings" (Chinese characters written with inappropriate or inaccurate strokes) and just two omitted words (words which have been written as supplements); therefore, among sixty-five thousand characters only one character has been supplementarily written, an extremely high rate of accuracy. Hearing this, this author feels there is no better expression of the human spirit! That is, this sagyeong relic is the product of the highest practice.

8) Sagyeong practice has been applied in different mediums. Although it basically belongs to the category of calligraphy (for it is the practice of copying the scriptures of the Buddhist masters), sagyeong practice has been adopted and developed in other fields such as painting, crafts, and sculpture. Accordingly, sagyoeng art can be said to be an 'art genre' which expands the area of calligraphy to the fullest. As far as sagyeong art is concerned, various forms, styles, and techniques have been accepted and developed by using various sorts of tools and materials, tools and materials that would be difficult to find in calligraphy. Sagyeong relics have been produced by using various materials, as follows: a woodblock scripture (a sagyeong work carved in a woodblock, which integrates calligraphy into a wooden sculpture); a stone scripture (a sagyeong work carved in a stone plate, which integrates calligraphy into a stone sculpture); a gold-plated scripture (a sagyeong work produced on a gold-plate, which integrates calligraphy and metal craft); a copperplate scripture (a sagyeong work carved in a copperplate, which is also an integration of calligraphy and metal craft); a jade scripture (a sagyeong work carved in jade, which is a combination of calligraphy and craft); a roof tile scripture (a sagyeong work carved and baked in a roof tile or pottery, which is the combination of calligraphy and pottery). Likewise, sagyeong relics have been produced in various ways by integrating calligraphy into sculpture, craft, and pottery. Moreover, sagyeong work has included paintings which were done to be the front cover of a book, and byeonsang-do (paintings which express the content of a scripture with pictures), and craft pieces such as gyeong-sim (the spindle of a scroll), gyeong-gap (a small storage box for sagyeong relics), gyeong-hap (a small storage bowl for sagyeong relics), gyeong-ham (a large storage box for sagyeong relics), and gyeong-gwe (a storage box for sagyeong relics).

9) Sagyeong works are the repository of the Dharma. Buddhist scriptures are records of teachings of the truth, subjects on which the greatest Buddhist masters in the history of mankind have preached. The copying of these scriptures could be said to be a basis of a religion in and of itself, in that without religious actions like this copying, a religion could not be established. In this respect, the Buddhist scriptures are identified with the

Buddha. That is, if the Buddha's body is the repository of the Buddhist spirit, a sagyeong relic becomes the body of the Dharma. Therefore, sagyeong relics have been revered as sacred treasures, that is, the body of the Dharma, and it is on the basis of such faith in the body of the Dharma that sagyeong relics have been very preciously enshrined inside Buddha statues and Buddha-stupas. The process of creating these sacred treasures, as the most important act of faith, can be said to be the very practice of practices, in which one receives the Buddha's teaching of truth most directly, through five clean senses. Since a sagyeong relic is an artwork created from samadhi (a powerful form of concentration related to meditation), it can be said to be the art of arts, in which precious human spirit is wholly contained.

10) Sagyeong practice is the oldest traditional form of Korean Buddhist practice, and the most excellent way of practice. Basically, it is a way of practice in which one copies the words of scriptures and disseminates the truth widely to benefit sentient beings, and at the same time to look oneself in the face. That is to say, since sagyeong practice benefits both myself and others, it becomes a practice that builds the greatest merit. On the other hand, since the object of sagyeong practice is the Tripitaka (the sutra-pitaka [a collection of sermons], the vinaya-pitaka [a collection of rules], and the abhidharma-pitaka [a collection of philosophical treatises]), works that have been revered as the Dharma treasures, one should first of all purify one's body, mind, materials, and tools to conduct sagyeong practice. Only if one gets out of craving, anger, and ignorance, can one put the Buddha's truth fully in the empty space. Unlike the other ways of practice that only regulate the mind, sagyeong practice tries to harmonize the cleanness of body and mind with the most precious materials and tools, so it becomes the most difficult, noble, and absolutely pure practice.

Traditional sagyeong practice has the longest tradition in Korea, and is the most excellent way of practice; furthermore, it is a culture and synthetic art that has significance and value from the viewpoint of world history ; and it aims for the cleanness of body and mind, the aesthetics of slowness and refinedness. Such an aesthetic of slowness and refinedness has merit, and the ability to contribute to the mutual prosperity of mankind. How? By enabling modern men, who are likely to overlook the value and meaning of a genuine life because of the excessive pursuit of material civilization, to reflect on the relationship between themselves, their neighbors and society, and to reveal their true humanity.

Oegil Kim Kyeong-Ho
Korea Traditional Skills Transmitter (Ministry of Employment and Labor)

## The Transmission and Creation of Traditional Sutra-Copying in Korea

## Sutra-Copying as Spiritual Discipline and as Art

1. Sutra copying

Buddhism is based on the 'three jewels' of Buddha, Dharma and Sangha. The Dharma, the teaching of the Buddha, is expressed in a large number of sutras (scriptures) which as such are the object of veneration. Copying the sutras using writing-brush and ink has long been practiced in Korea.

Sutra-copying began with the first writing down of the Buddhist scriptures. In Korea, it began with the first introduction of Buddhism into the Three Kingdoms of Korea in the 4th century of the current era.

It flourished especially during the Koryeo era (918-1392), when Buddhism enjoyed royal patronage, and has been practiced in one form or another as a spiritual discipline ever since.[1]

2. At first the sutras were copied out by hand in order to make the words of the Buddha accessible far and wide but later, after printing had been invented, the task of spreading the Buddha's message was taken over by prints made from woodblocks[2], and copying the sutras by hand was practiced as a means of acquiring merit or of disciplining and purifying the body and mind.

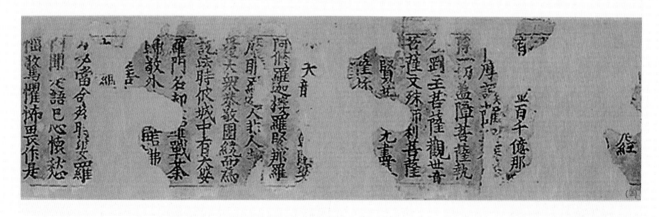

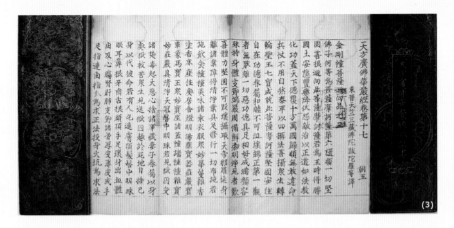

For as the words of the Buddha were transcribed one by one, they were inscribed on the writer's heart, serving as the most effective way of deepening one's faith in and understanding of them.

As the highest form of devotion and practice, in the most elaborate and formal process precious materials such as gold and silver came to be used.

3. The art of sutra-copying involves a variety of skills: the preparation and production of the materials, the method of binding the pages, the art of calligraphy.

Depending on the materials used, sutras may be written in ink[3], in powdered gold[4] or in powdered silver[5].

The practice of using gold or silver for writing the sutras is assumed to date from the Three Kingdoms period (4th-6th centuries). From the 9th century onward, during the United Silla period, gold was used to write out whole collections of the Buddhist scriptures. More than ten sets of the scriptures written in gold or silver were made in the Koryeo era.

Since complete collections of the scriptures in gold or silver were usually made under the sponsorship of the state

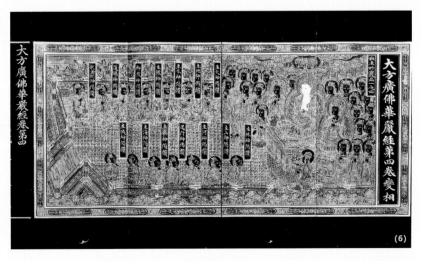

or the king, they were made with outstanding levels of skill(6).

In and about the 14th century, on several occasions Korean experts in writing the sutras using gold and silver were summoned to China to write sutras there, a sign that at that time Korea's skills were recognized as unequalled throughout the Far East.

4. There are two main methods for making the copies. In the first, the writing is done directly onto paper or silk, using ink, gold or silver. In the second, the materials undergo a transformation. This second method has many varieties; the text may be engraved onto thinly beaten sheets of gold(7), bronze (copper) or stone(8), or on clay(9) which is then baked.

Bindings are of various kinds: in scroll format(10), folded (like a screen)(11), or with binding like any book (bound on the right)(12).

In addition, the text may be written in Chinese characters, or in the Korean hangeul alphabet.

5. Since sutra-copying is a spiritual exercise that involves writing the words of the Buddha on one's heart at the same time as on paper(13), great devotion and seriousness are required at every stage. This can be seen from records suggesting that the person writing used to perform a triple prostration for every character written.

All of these stages and aspects can be clearly seen in the colophon (concluding note indicating the purpose,

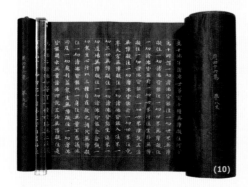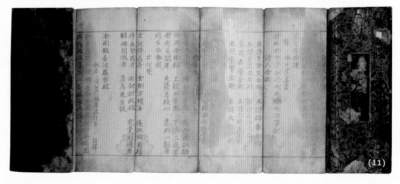

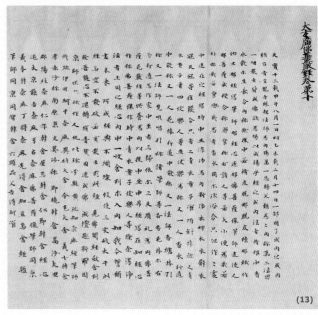

process and date of the work) of the earliest example, the Silla-era Avatamsaka Sutra written in ink on paper: 'The paper-mulberry trees, from which is made the paper for the sutras, are watered with perfumed water as they grow. The people involved in every stage of making sutras must have taken the Bodhisattva Vow. If they go to relieve themselves, sleep, or eat, during the work, they are obliged to wash, bathing in perfumed water, before returning to the place where the sutra is being copied.'

Purifying body and heart before proceeding with the sutra-copying in a devout and solemn manner shows to what extent it was considered as a spiritual exercise in Buddhist tradition.[14]

6. Before beginning, first the sutra to be copied must be selected and the copy checked for wrong or missing characters. Then the most appropriate format, materials and tools are chosen.

When using paper, mulberry paper is employed; if gold or silver are to be used, the paper should be dyed using a color that will show off well the color of the text.

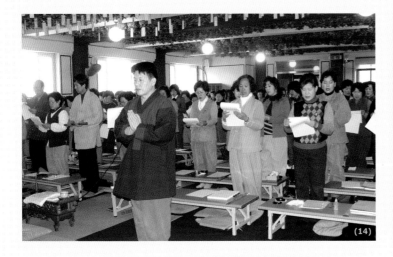

  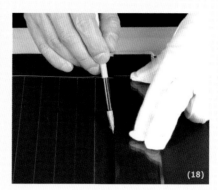

(16) (17) (18)

The paper is given at least three coats of ox-hide starch[15]; this gives the paper a higher density, helpful for writing, and makes it more resistant to heat and humidity.

The powdered gold or silver is mixed with a base made of the highest quality deer-horn gelatin for writing[16].

The powdered gold and silver are refined at least three times to remove impurities[17], to ensure that the writing is as regular as possible.

7. Once all is ready, the writing begins. First, vertical and horizontal guide-lines are ruled[18].

The cover is the first part to be written. Each of the designs and patterns used should indicate eternal life, purity of heart, good fortune etc.[19],

Next a prefatory painting is made, illustrating the contents of the sutra[20]. The borders are decorated with wheels (symbolizing the truth of the Buddha's message spreading across the world) or diamond vajras (defending the truth of the Buddha's message)[21].

8. Sometimes in the painting the celestial gods are portrayed around their king[22], indicating that they protect the person copying the sutra as well as all involved in making it, or reading it, from all evil and misfortune.

The text of the sutra itself is written with the utmost care, avoiding the slightest irregularity, in the most refined style of script available[23].

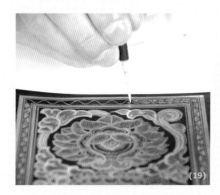 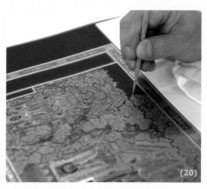 

(19) (20) (21)

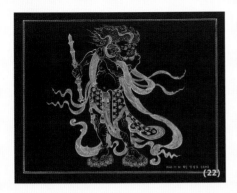

Once the sutra has been fully copied, a colophon is added containing prayers that the Buddha's truth may endure for ever, prayers for peace, blessings on those around and on the person writing, as well as an explanation of the reason for copying the sutra, the process followed, and the date[24].

When gold or silver are used, the surface is polished to shine like the Buddha's truth.

Once the entire process has been completed, if the format is a scroll the central core has to be made.

9. Sutra-copying has involved, for the 1700 years of its history, transcribing the words of the Buddha character by character with the greatest of care, intent on shedding ever more light on the wisdom and compassion expressed therein[25].

Sutra-copying, writing out the teaching of the Buddha, inscribing it in one's heart, and putting it into practice as an expression of one's desire for enlightenment, is a crystallization of faith brimming with the spirit that inspired our ancestors, yielding outstanding works of art expressive of the purest spiritual practice of Buddhism, transcending time and space, still living and breathing today as it did throughout our country's history[26].

Translation ;
An Sonjae is the Korean name of Brother Anthony of Taizé, who was born in 1942 in England. Since 1980, he has been living in Korea, teaching at Sogang University in Seoul, where he is now an Emeritus Professor. He has published over 20 volumes of English translations of modern Korean literaturem as well as a guide to the Korean Way of Tea.

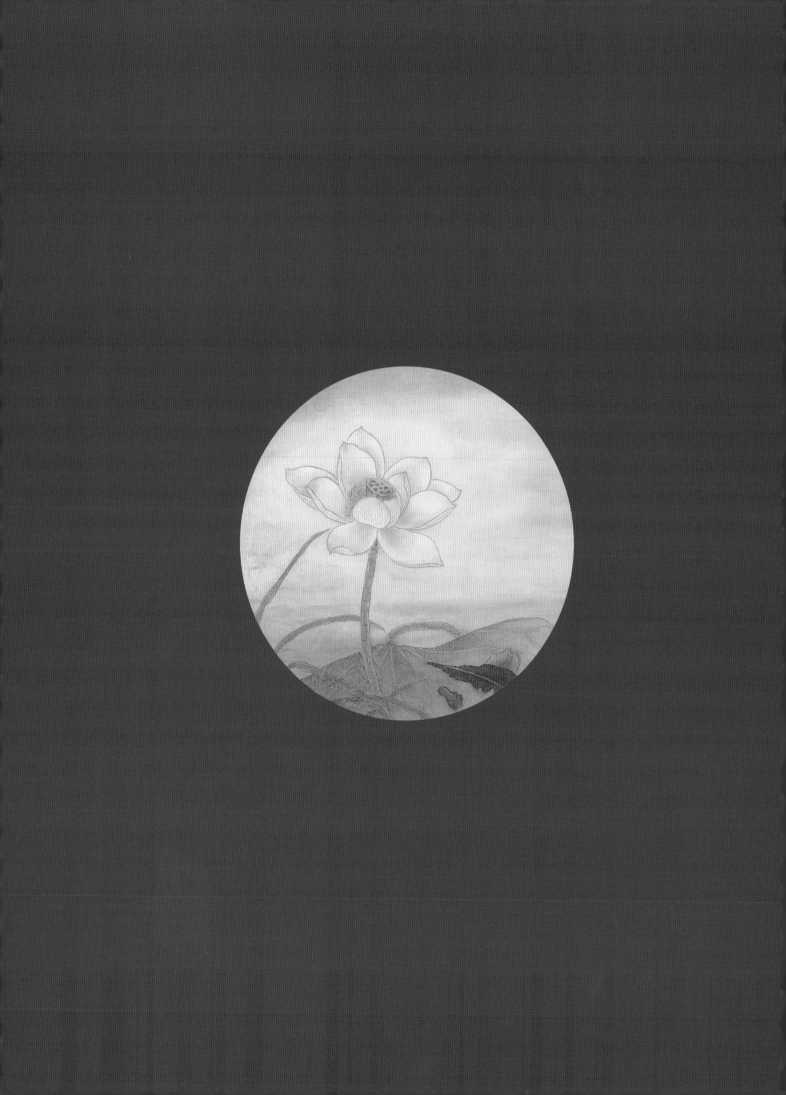

## Chapter 3: Chapter of Happiness

Shin-Ae Kang

Keun-Hong Kim

Gyoung-Bin Park

Yeon-Ji Park

Jin-Hee Park

Jeong-Min Song

Kang-Hee Lee

Kyung-Ja Lee

Kye-Hee Lee

Soon-Rae Lee

Eun-Jung Lee

Hyang-Ja Jeong

Kyung-Hee Jo

Yun-Jin Joo

Joon-An(Dharma name)

 : Byung-Mo Kim

Ae-Suk Choi

# Shin-Ae Kang

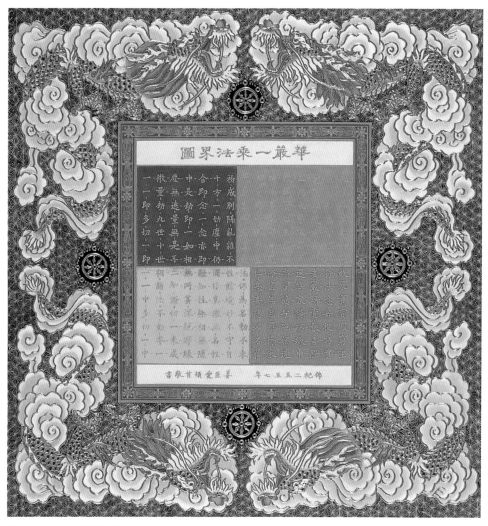

The Hwaeom One Vehicle Dharma Realm Chart / *Silk, a gold leaf, drawing technique for white porcelain, a gold amalgam,*
*50 × 52 ㎝*

· Invited Artist, Competition in Calligraphy and Culture

· Prizewinner at many calligraphy and sutra transcription Competitions

· Participated in the exhibitions of the Korean Transcribed Sutra Research Association members

· 204-703, Doosan Weve Apt, Samga-dong, Cheoin-gu, Yongin-si, Gyeonggi-do, South Korea

· Mobile. +82+10-9705-5077

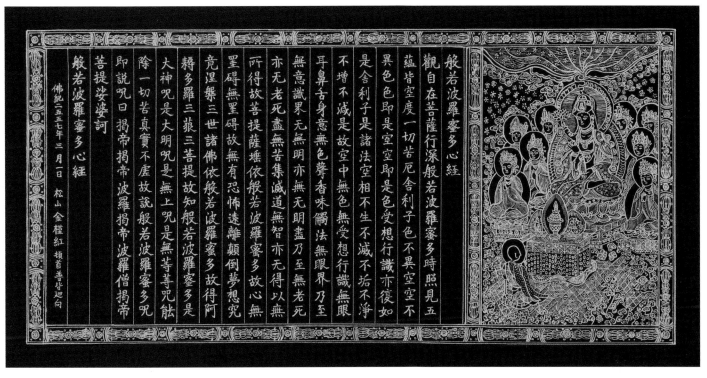

The Heart Sutra / *indigo blue paper, a gold amalgam,  28 × 60㎝*

· Invited Artist, Competition in Calligraphy and Culture
· Participated in the exhibitions of the Korean Transcribed Sutra Research Association members
· Prizewinner at many calligraphy and sutra transcription Competitions

· 13ho, 2gil Sohag, Seonnam-myeon, Seongju-gun, Gyeongsangbuk-do, South Korea, 719-832
· Mobile. +82+10-9233-1368

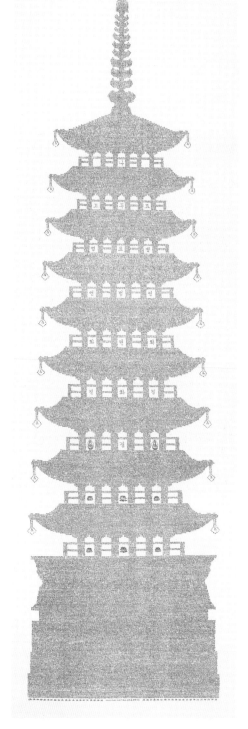

The Picture of the Jeweled Pagoda in the Lotus Sutra /
*traditional Korean paper handmade from mulberry trees, ink
stick, 200 × 70 cm*

· Invited Artist, Competition in Calligraphy and Culture
· Participated in the exhibitions of the Korean Transcribed Sutra Research Association members
· Invited Artist, Prizewinner at many calligraphy and sutra transcription Competitions

· 110-306, Muak cheonggu Apt, Hongje 2-dong, Seodaemun-gu, Seoul, South Korea
· Mobile. +82+10-5447-8487

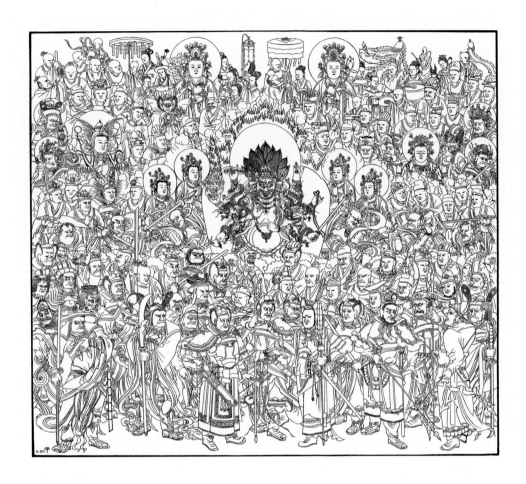

Image of 104 divine guardians of Buddha / *traditional Korean paper handmade from mulberry trees, ink stick, 40 × 45㎝*

· Participated in the exhibitions of the Korean Transcribed Sutra Research Association members
· Prizewinner at many calligraphy and sutra transcription Competitions

· 329-3 Yangguen-ri, Yangpyeong-eup, Yangpyeoung-gun, Gyeonggi-do, South Korea
· Mobile. +82+10-8782-3169

# Jin-Hee Park

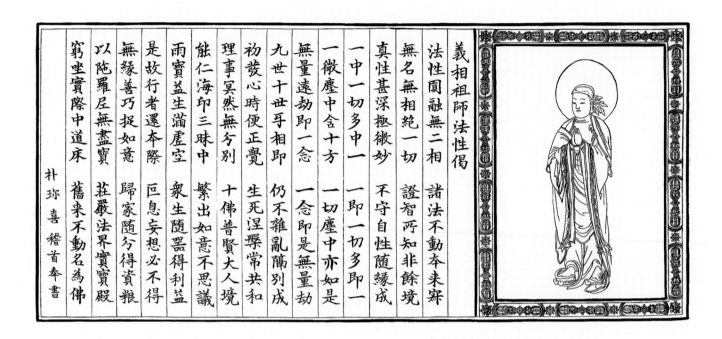

Master Uisang's Beopseong-ge (Verse of Dharma Nature) / *traditional Korean paper handmade from mulberry trees, ink stick, 22.5×50㎝*

· Participated in the exhibitions of the Korean Transcribed Sutra Research Association members

· Prizewinner at many calligraphy and sutra transcription Competitions

· 102-204 Dongsin Apt, 37-24 Hyeoisan-ro, Anseong-si, Gyeonggi-do, South Korea, 456-708

· Mobile. +82+10-4038-8199

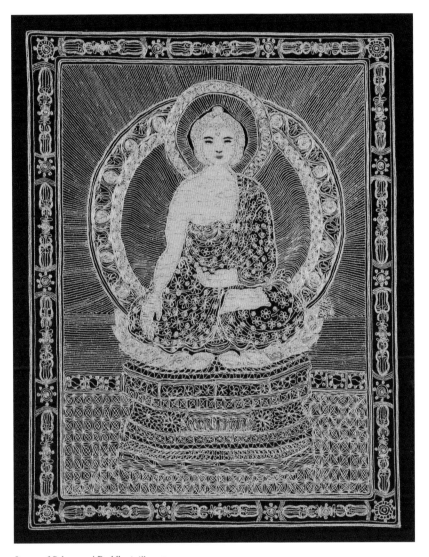

Image of Sakyamuni Buddha / *silk, cotton*

· Participated in the exhibitions of the Korean Transcribed Sutra Research Association members
· Prizewinner at many calligraphy and sutra transcription Competitions

· 102-105 Cheonwang Yeonji Town, 30 Oryu-ro, Guro-gu, Seoul, South Korea
· Mobile. +82+10-7578-7630

# Kang-Hee Lee

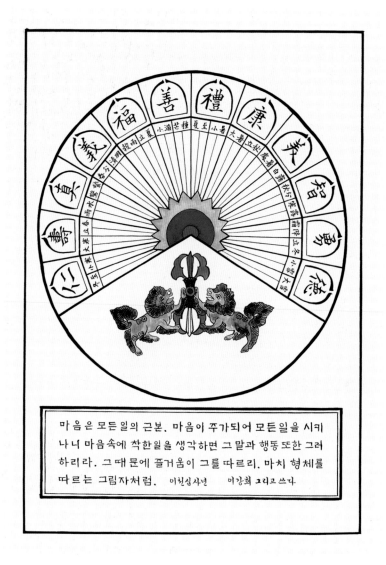

<New Year's Wish> Mandala / *traditional Korean paper handmade from mulberry trees, Ink Stick, color paint, 42×30㎝*

· Participated in the exhibitions of the Korean Transcribed Sutra Research Association members
· Prizewinner at many calligraphy and sutra transcription Competitions

· 402 Aram villa, 205-5, Jamsil-dong, Songpa-gu, Seoul, South Korea
· Mobile. +82+10-5600-9860

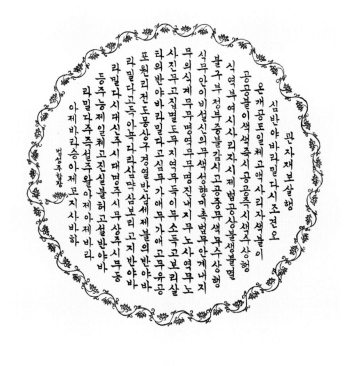

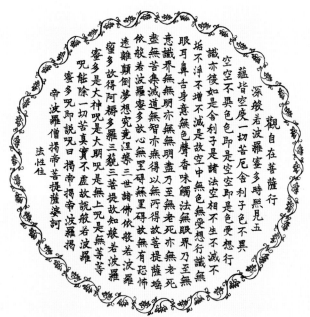

The Heart Sutra / *traditional Korean paper handmade from mulberry trees, Ink Stick,*
*color paint, 35×35cm×2*

· Invited Artist, Competition in Calligraphy and Culture
· Participated in the exhibitions of the Korean Transcribed Sutra Research Association members
· Prizewinner at many calligraphy and sutra transcription Competitions

· 69-12 Younhee 3-dong, Seodaemun-gu, Seoul, South Korea
· Mobile. +82+10-2244-5577

# Kye-Hee Lee

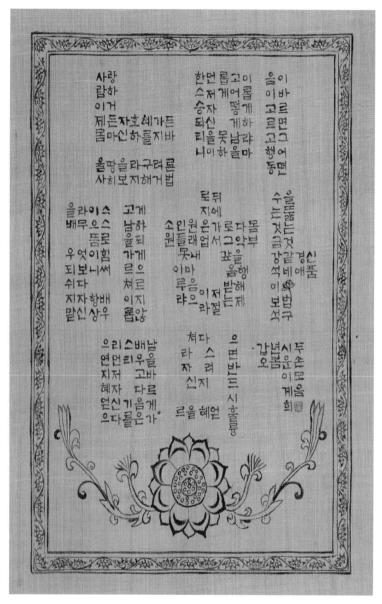

Dhammapada / *ramie fabric, Ink Stick, 36×27㎝*

· Invited Artist, Competition in Calligraphy and Culture
· Participated in the exhibitions of the Korean Transcribed Sutra Research Association members
· Invited Artist, Prizewinner at many calligraphy and sutra transcription Competitions

· Dongil Apt. 304-301, 34-16 Singok-ro 3 beon-gil, Gochon-eup, Gimpo-si, Gyeonggi-do, South Korea
· Mobile. +82+10-6218-6014

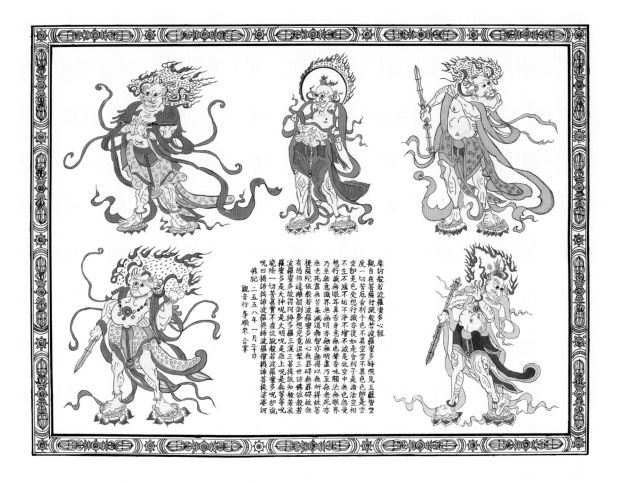

The Picture of the Guardian Generals in Goryeo's Sutra-Copying Works / *traditional Korean paper handmade from mulberry trees, Ink Stick, color paint,*
*50×63cm*

· Participated in the exhibitions of the Korean Transcribed Sutra Research Association members
· Prizewinner at many calligraphy and sutra transcription Competitions

· 101-203 Dongkwang-ro 32-gil 7, Seocho-gu, Seoul, South Korea
· Mobile. +82+10-5067-5156

# Eun-Jung Lee

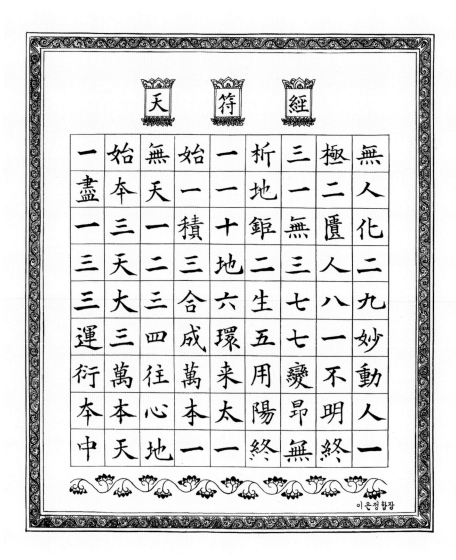

Cheonbugyeong (The Law of Heaven's Symbols) / *traditional Korean paper handmade from mulberry trees, ink stick, 27×23㎝*

· Participated in the exhibitions of the Korean Transcribed Sutra Research Association members
· Prizewinner at many calligraphy and sutra transcription Competitions

· 101-1008 Daedong 1cha Apt, 604-11, Gongneung1,3 dong, Nowon-gu, Seoul, South Korea
· Mobile. +82+10-9329-8694

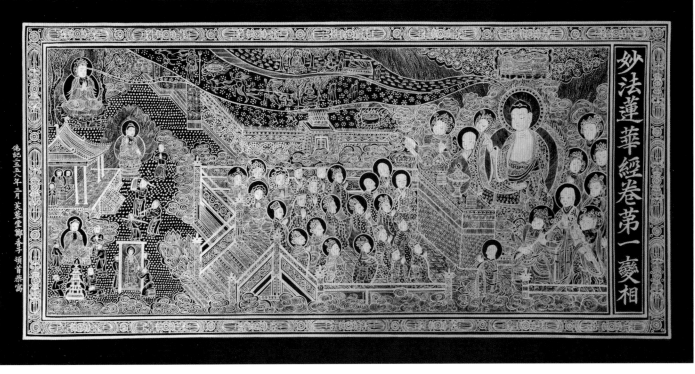

妙法蓮華經卷第一變相

The Illustrated Painting of the Lotus Sutra Vol. 1 / *indigo blue paper, a gold amalgam, 26×55㎝*

· Private Exhibitions of Sutra Transcription
· Participated in the exhibitions of the Korean Transcribed Sutra Research Association members
· Invited Artist, Prizewinner at many calligraphy and sutra transcription Competitions
· Invited to the Sutra Transcription Exhibit at the World Calligraphy Biennale of Jeollabuk-do

· Flat No.610 Block No.106, Hyundai Apt, Hwajung 1-dong, Westdist, Gwangju, Korea
· Mobile. +82+10-4329-3581

# Kyung-Hee Jo

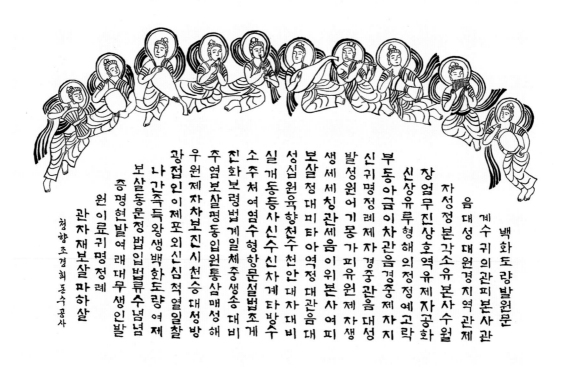

Baekhwa doryang barwon mun (Vow Made at the White Lotus Enlightenment Site) / *traditional Korean paper handmade from mulberry trees, ink stick, 34 × 44㎝*

백화도량발원문
계수귀의관피본사관
음대성대원경지역관제
자성정본각소유본사수월
장엄무진상호역유제자공화
신상유루형해의정정예고락
부동아금이차관음경중제자지
신귀명정례제자경중관음대성
발성원어기몽가피유원제자생
생세세칭관세음이위본사여피
보살정대미타아역정대관음대
성십원육향천수천안대자대비
실개동사신수신차계타방수
소주처여염수형항문설법조게
진화보령법계일체중생송대비
주염보살평동입원통삼매성해
우원제자차차보진시천승대성방
광접인이제포외신심적열일찰
나간족득왕생백화도량여제
보살동문정법입법류수념념
증명현발여래대무생인발
원이료귀명정례
관자재보살마하살
청향조경희돈수공사

· Participated in the exhibitions of the Korean Transcribed Sutra Research Association members

· Invited Artist, Prizewinner at many calligraphy and sutra transcription Competitions

· 117-1402ho, Dream Town Apt. Gwanak, 80 Seonghyeon-ro, Gwanak-gu, Seoul, South Korea

· Mobile. +82+10-8982-1177

信心銘

至道無難　唯嫌揀擇　但莫憎愛　洞然明白
六塵不惡　還同正覺　智者無為　愚人自縛
毫釐有差　天地懸隔　欲得現前　莫存順逆
法無異法　妄自愛著　將心用心　豈非大錯
違順相爭　是為心病　不識玄旨　徒勞念靜
迷生寂亂　悟無好惡　一切二邊　良由斟酌
圓同太虛　無欠無餘　良由取捨　所以不如
夢幻空華　何勞把捉　得失是非　一時放卻
莫逐有緣　勿住空忍　一種平懷　泯然自盡
眼若不睡　諸夢自除　心若不異　萬法一如
止動歸止　止更彌動　唯滯兩邊　寧知一種
一如體玄　兀爾忘緣　萬法齊觀　歸復自然
一種不通　兩處失功　遣有沒有　從空背空
泯其所以　不可方比　止動無動　動止無止
多言多慮　轉不相應　絕言絕慮　無處不通
兩既不成　一何有爾　究竟窮極　不存軌則
歸根得旨　隨照失宗　須臾返照　勝卻前空
契心平等　所作俱息　狐疑淨盡　正信調直
前空轉變　皆由妄見　不用求真　唯須息見
一切不留　無可記憶　虛明自照　不勞心力
二見不住　慎莫追尋　纔有是非　紛然失心
非思量處　識情難測　真如法界　無他無自
二由一有　一亦莫守　一心不生　萬法無咎
要急相應　唯言不二　不二皆同　無不包容
無咎無法　不生不心　能隨境滅　境逐能沉
十方智者　皆入此宗　宗非促延　一念萬年
境由能境　能由境能　欲知兩段　元是一空
無在不在　十方目前　極小同大　忘絕境界
一空同兩　齊含萬象　不見精麤　寧有偏黨
極大同小　不見邊表　有即是無　無即是有
大道體寬　無易無難　小見狐疑　轉急轉遲
若不如此　不必須守　一即一切　一切即一
執之失度　必入邪路　放之自然　體無去住
但能如是　何慮不畢　信心不二　不二信心
任性合道　逍遙絕惱　繫念乖真　昏沉不好
言語道斷　非去來今
不好勞神　何用疏親　欲趣一乘　勿惡六塵

僧璨　著

佛紀二五五八年夏　素田　朱玧賑　恭書

The Xinxin Ming (A one-fascicle work on the essence of Buddhist faith by the third Chan patriarch Sengcan) / *traditional Korean paper handmade from mulberry trees, ink stick, 50×40㎝*

· Participated in the exhibitions of the Korean Transcribed Sutra Research Association members
· Prizewinner at many calligraphy and sutra transcription Competitions

· 114-504ho, 10  348gil, Naedong-ro, Jinju-si, Gyeongsangnam-do, South Korea
· Mobile. +82+10-8539-4479

# Joon-An (Dharma name) : Byung-Mo Kim

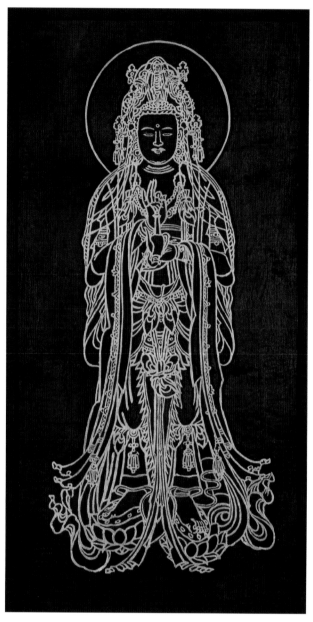

The Picture of Avalokiteshvara / *wood, a gold amalgam, 65 × 34㎝*

· Participated in the exhibitions of the Korean Transcribed Sutra Research Association members
· Prizewinner at many calligraphy and sutra transcription Competitions

· Beobryun-sa Bulyeoseong, 112 Sagan-dong, Jongno-gu, Seoul, South Korea
· Mobile. +82+10-3621-5539

佛説尊勝陀羅尼呪

The Dharani of the Jubilant Corona, Whose Powers Can Prolong Life and Destroy the Hardships of Transmigration /
*traditional Korean paper handmade from mulberry trees, red ink stick, 43×45cm*

· Participated in the exhibitions of the Korean Transcribed Sutra Research Association members
· Prizewinner at many calligraphy and sutra transcription Competitions

· 302ho, 34gil, Simgok-ro, Sosa-gu, Bucheon-si, Gyeonggi-do, South Korea
· Mobile. +82+10-8561-5638

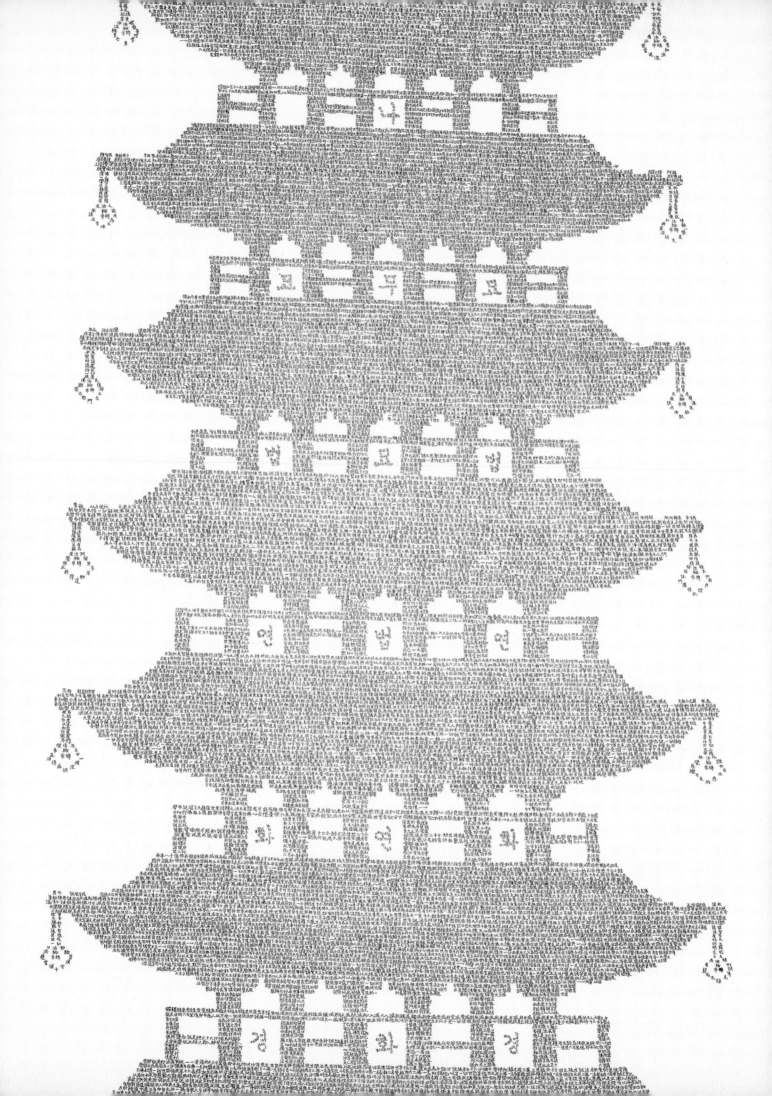

# Chapter 4: Photo history of Korean Transcribed Sutra Research Association

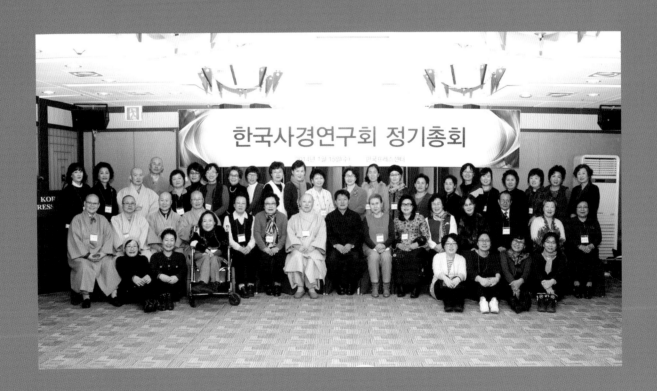
한국사경연구회 정기총회

# ◈ Recent Activities of Korean Transcribed Sutra Research Association

Special lecture on traditional sutra transcription-Advanced Calligraphy Program, Grduate School of Education, Korea University (2007.4)

Special Exhibition of Sutra Transcription-National Museum of Korea (2007.8)

Special lecture on traditional sutra transcription-Woljeon Museum (2008.8)

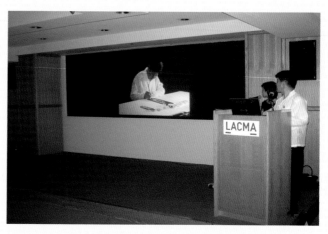

Special lecture on traditional sutra transcription-LA County Museum of Art (2010.8)

Demonstration of sutra transcription in gold ink-LA County Museum of Art (2010.8)

Special lecture-LA County Museum of Art (2010.8)

Special lecture on traditional sutra transcription-World Calligraphy Biennale (2011.10)

Special lecture-Won Myung temple, Los Angeles (2012.4)

Demonstration of sutra transcription in gold ink-Town Hall, Flushing, NY (2012.10)

Special lecture-Town Hall, Flushing, NY (2012.10)

Special lecture-Dongguk University (2012.6)

Demonstration of sutra transcription in gold ink-Gallery Ho, New York, NY (2014.4)

# ◈ Korean Transcribed Sutra Research Association Exhibitions

Inaugural Invitational Exhibition (Seoul, 2002.12)

2nd Member Exhibition (Daegu, 2005.9)

3rd Member Exhibition (Jinan, China, 2007.5)

4th Invitational Exhibition (Seoul, 2008.10)

5th Member Exhibition (Seoul, 2010.5)

6th Member Exhibition (Seoul, 2011.6)

7th Invitational Exhibition (New York, 2012.10)

8th Member Exhibition (Daegu, 2013.5)

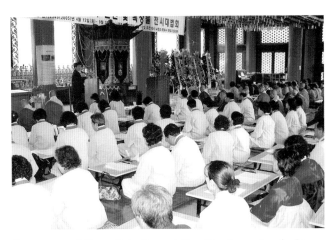

Reenactment of Koryo Sutra Transcription, Donghwasa temple, Daegu (2005.4)

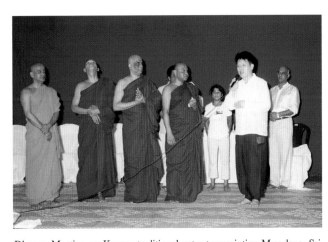

Dharma Meeting on Korean traditional sutra transcription-Maradana, Sri Lanka (2006.4)

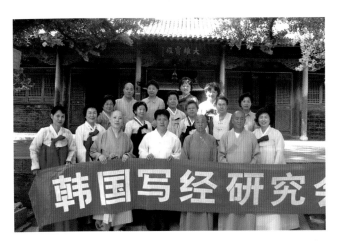

Dharma Meeting on Korean traditional sutra transcription-Lingyan Temple, China (2007.5)

Production and dedication of transcribed sutra-Claremont Lincoln University, Clairemont, CA (2012.4)

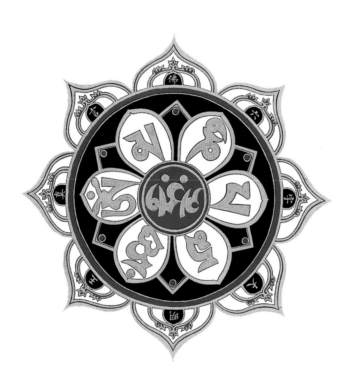